THE CITY
A Vision in Woodcuts

Frans Masereel

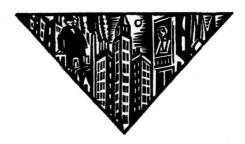

DOVER PUBLICATIONS, INC.
MINEOLA, NEW YORK

Bibliographical Note

This Dover edition, first published in 2006, is an unabridged republication of the work originally published as *Die Stadt* by Kurt Wolff Verlag AG, Munich, in 1925. The blank pages backing up the woodcut illustrations have been eliminated for this Dover edition.

Library of Congress Cataloging-in-Publication Data

Masereel, Frans, 1889–1972.
　[Stadt. English]
　The city : a vision in woodcuts / Frans Masereel.
　　p. cm.
　ISBN-13: 978-0-486-44731-5 (pbk.)
　ISBN-10: 0-486-44731-6 (pbk.)
　　1. Masereel, Frans, 1889–1972—Catalogs. 2. City and town life in art—
Catalogs. I. Title.

NE1155.5.M3A4 2005
769.92—dc22

2005054942

Manufactured in the United States by Courier Corporation
44731604
www.doverpublications.com

THE CITY
A Vision in Woodcuts

"This is the city and I am one of the citizens,
Whatever interests the rest interests me...."
—Walt Whitman

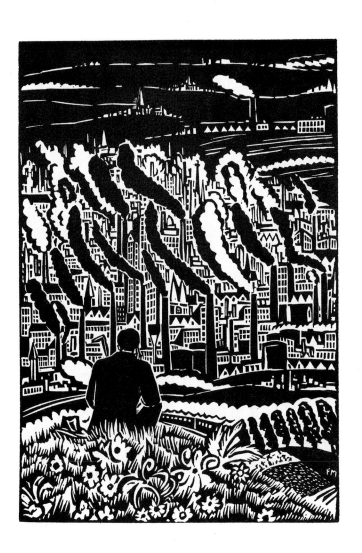

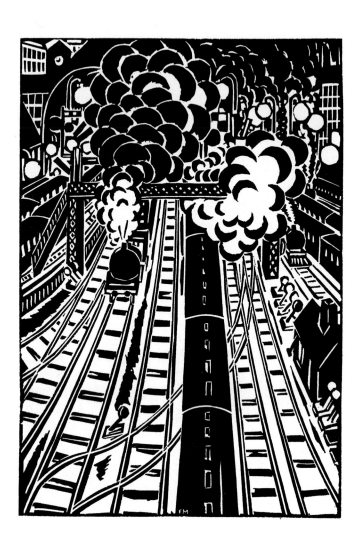

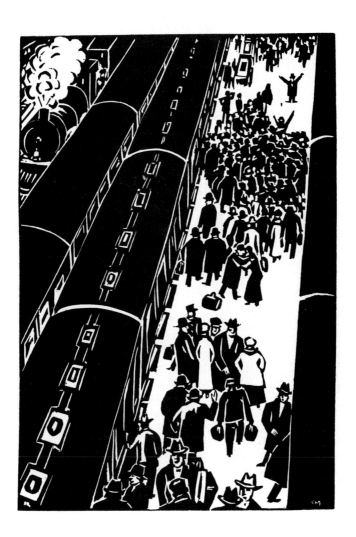

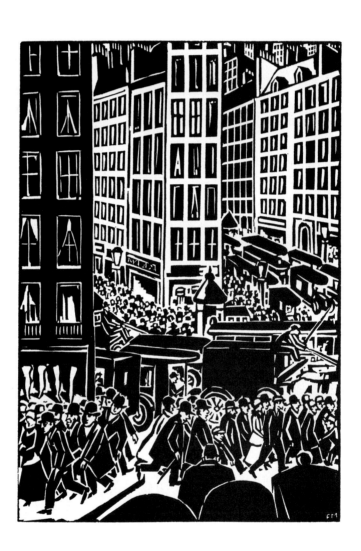

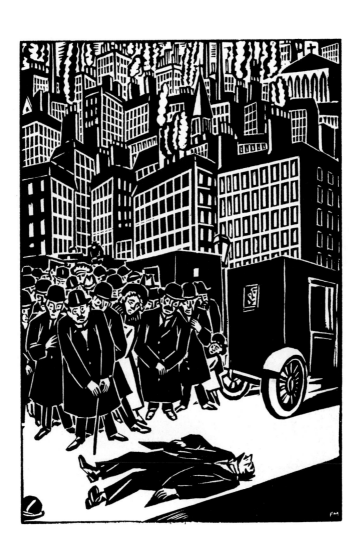

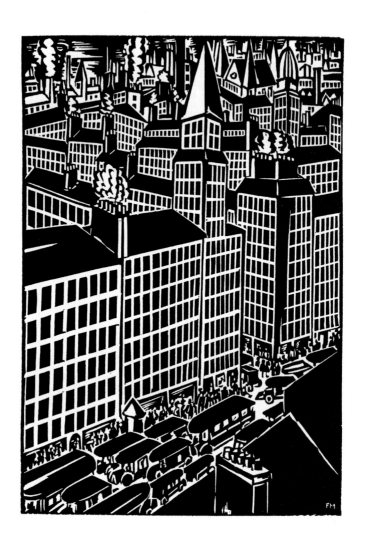

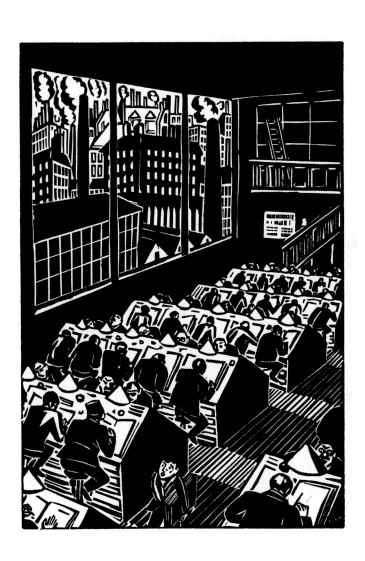

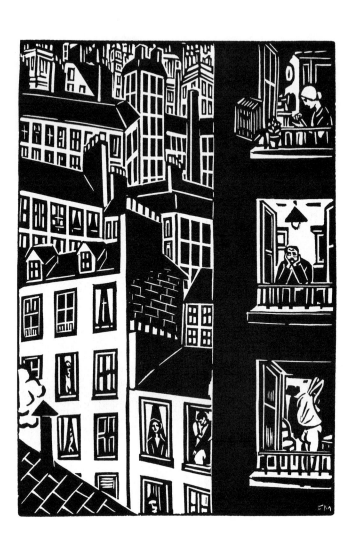

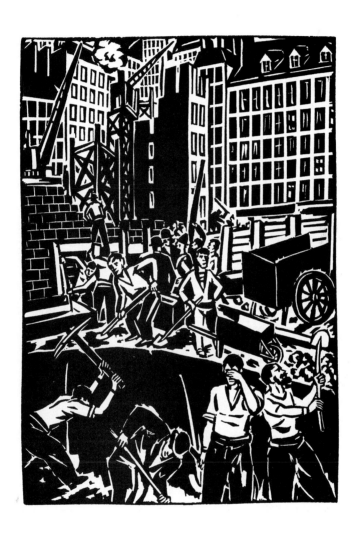

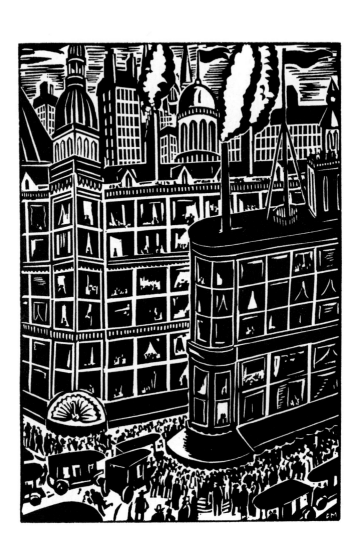

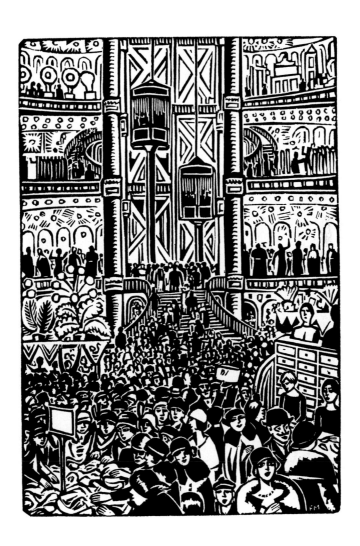

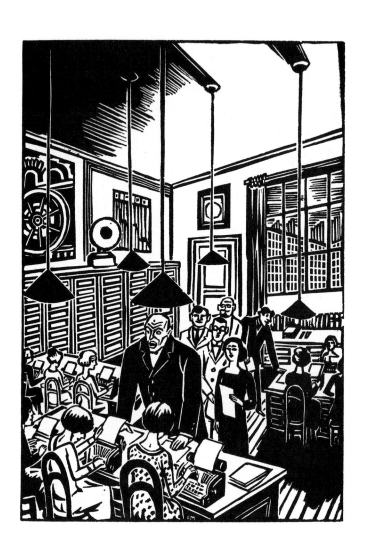

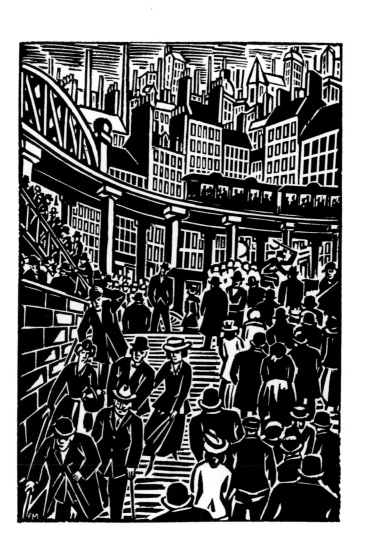

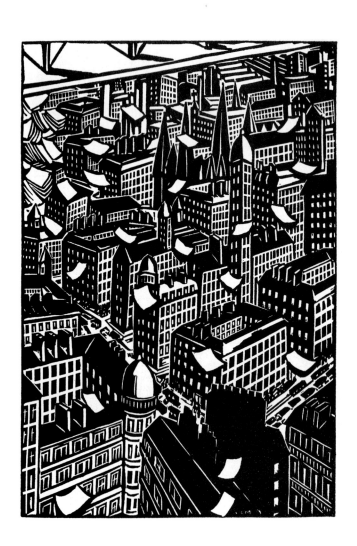

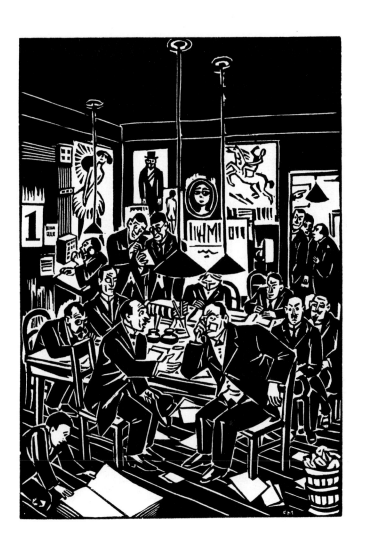

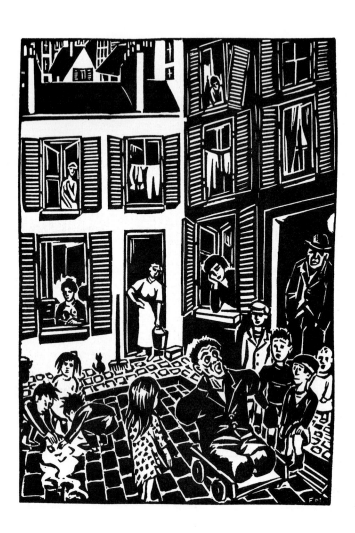

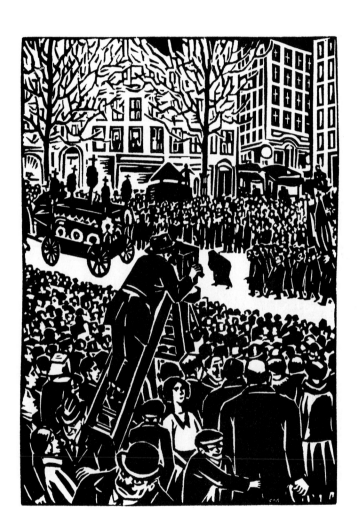

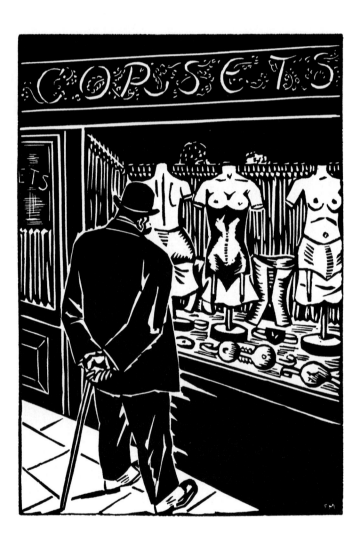

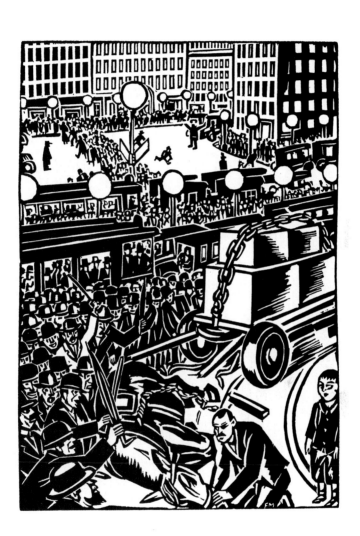

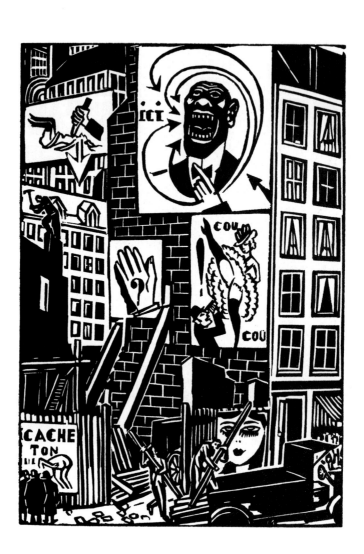

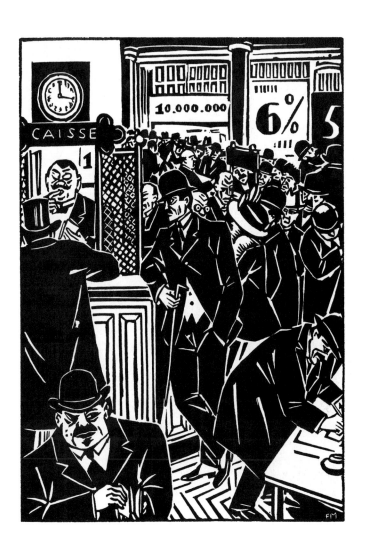

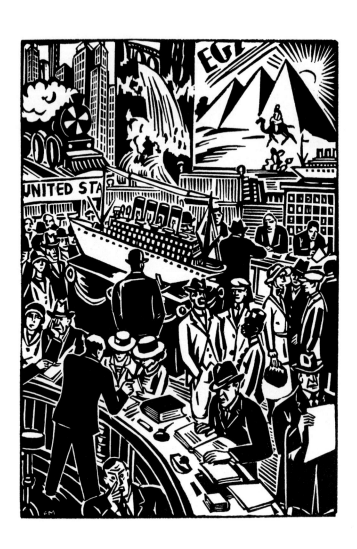

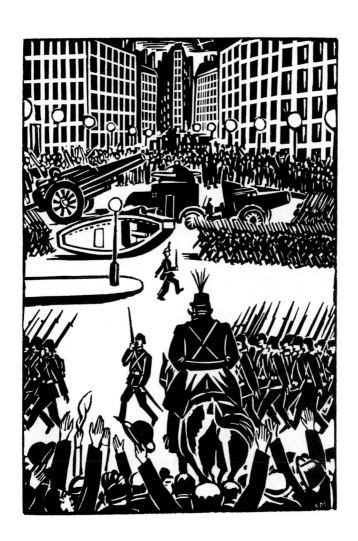

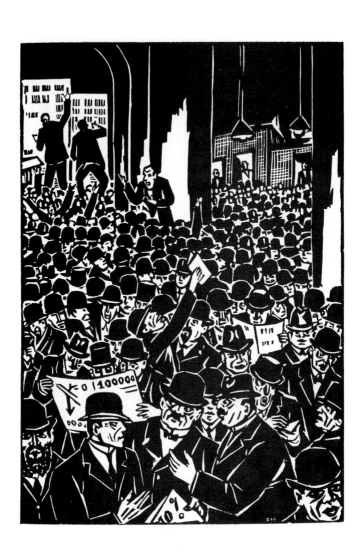

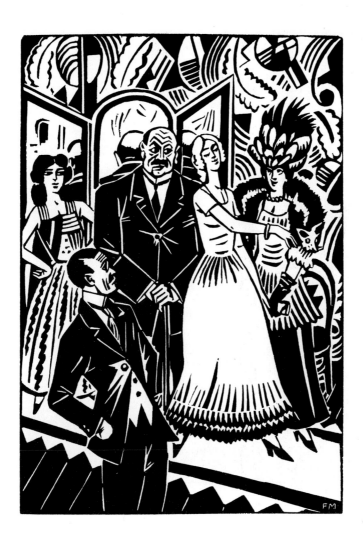

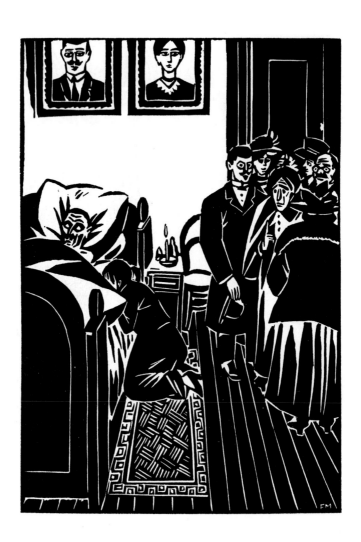

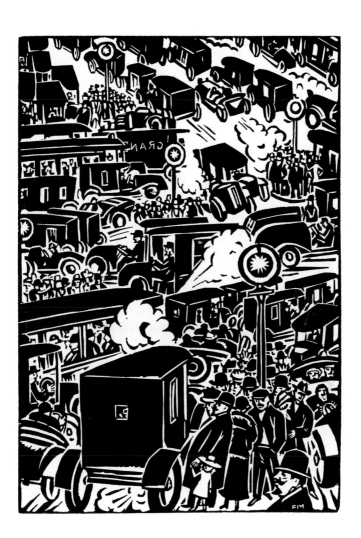

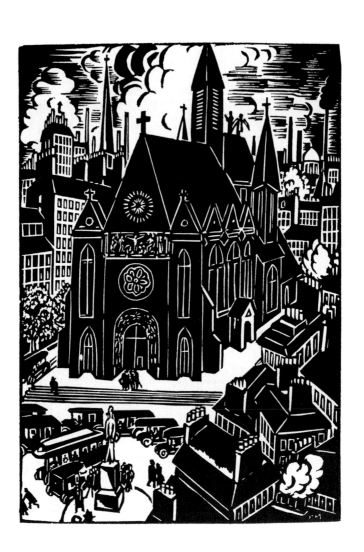

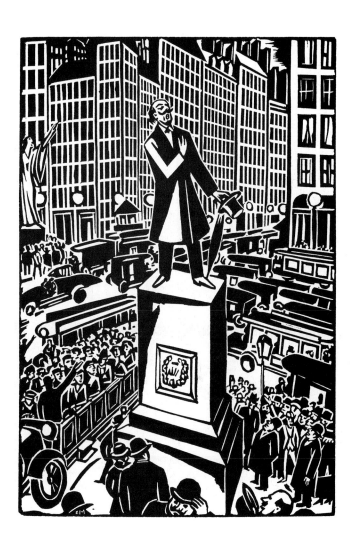

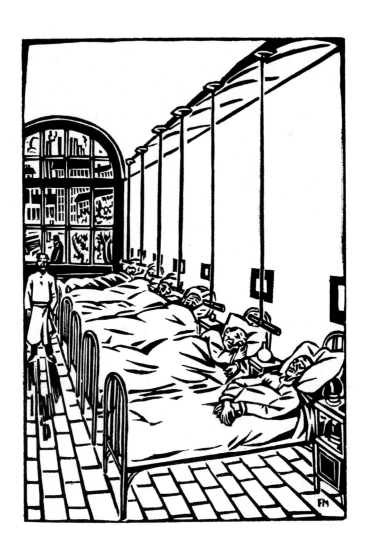

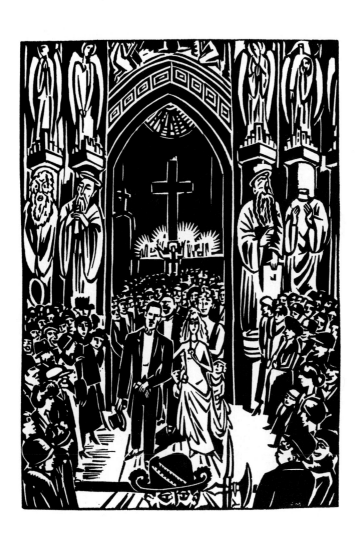

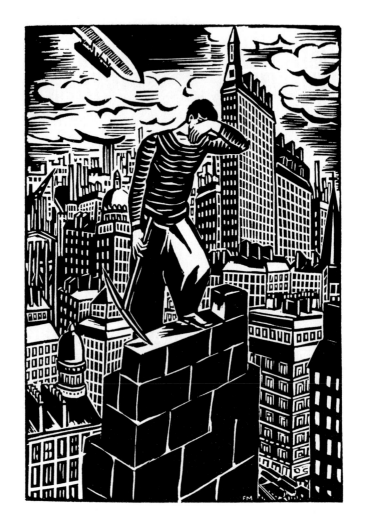

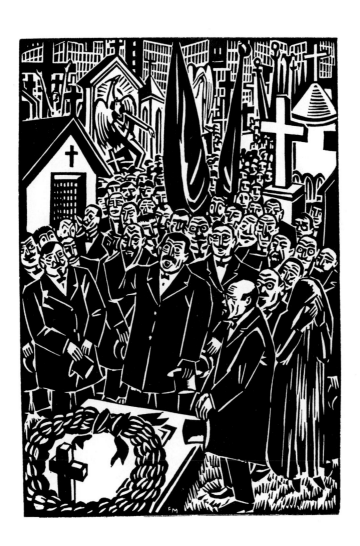

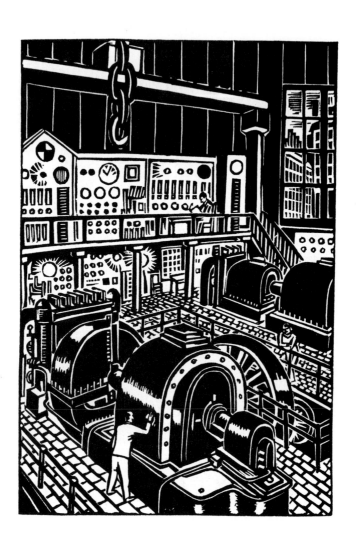

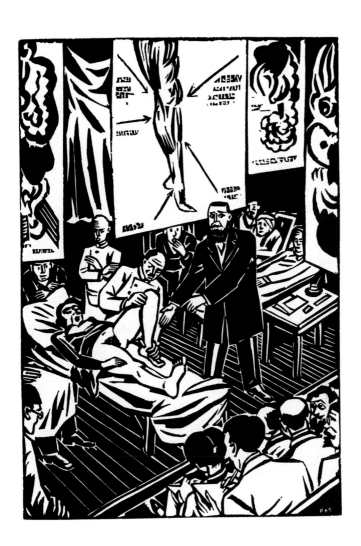

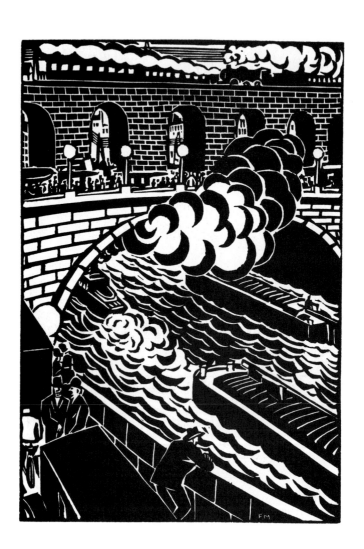

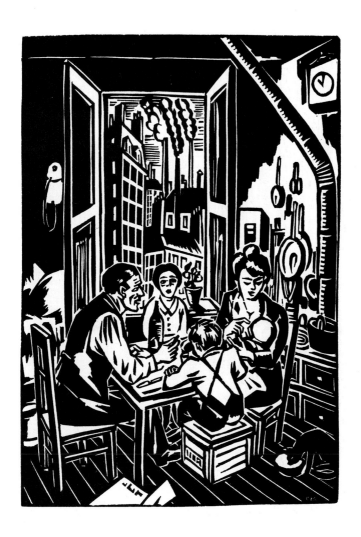

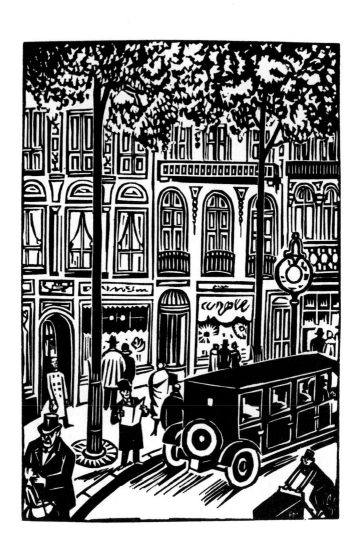

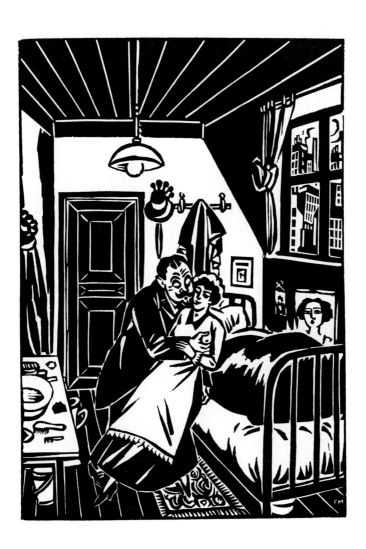

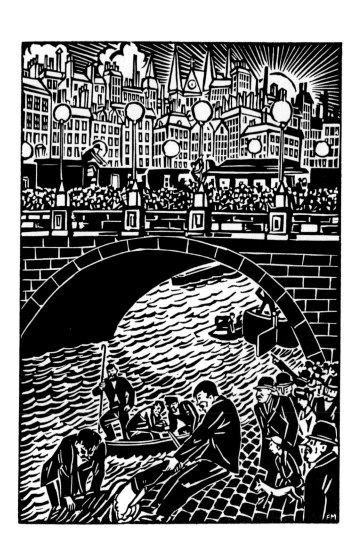

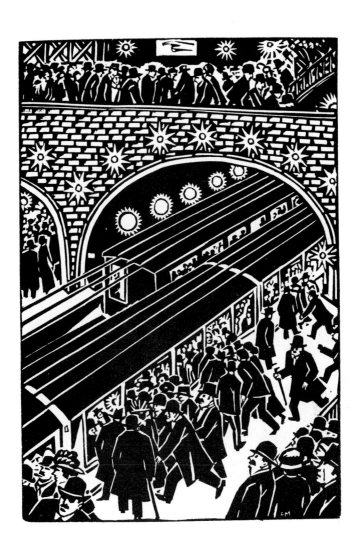

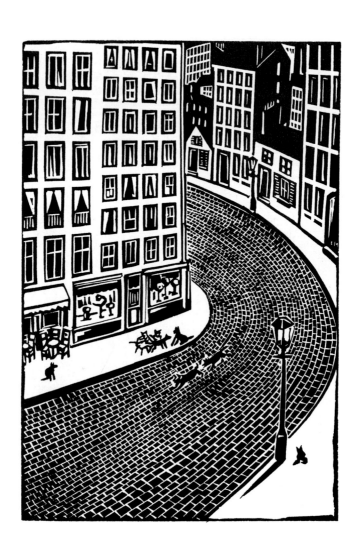

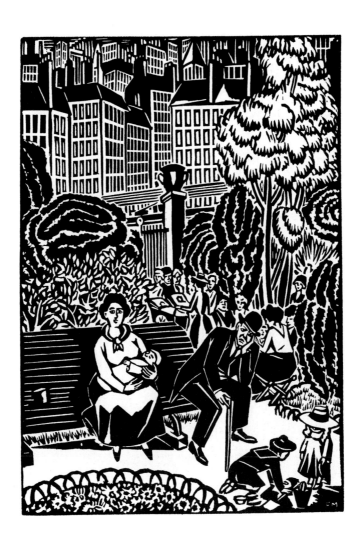

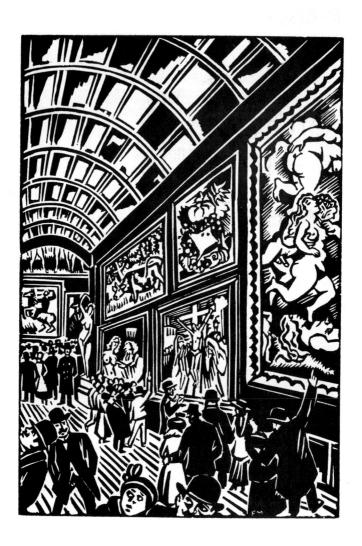

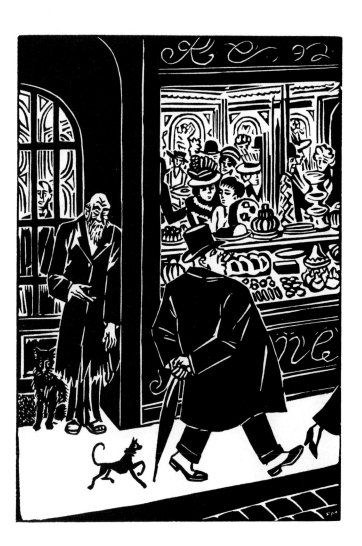

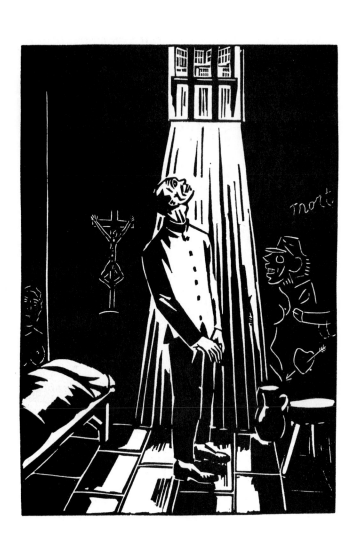

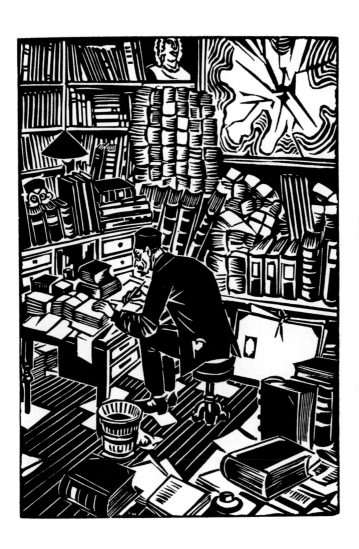

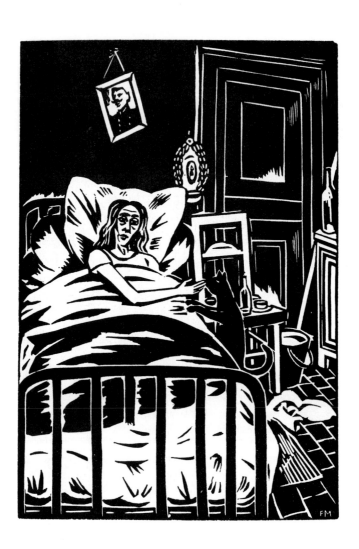

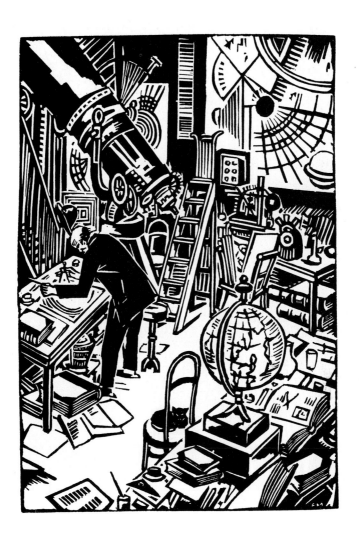

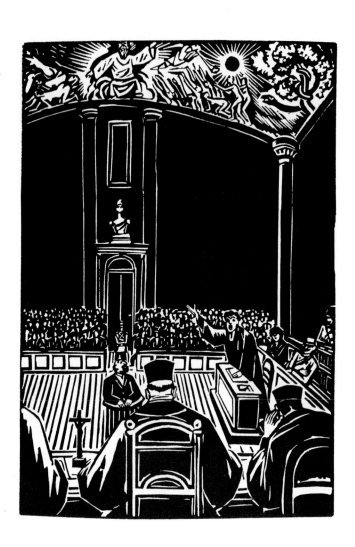

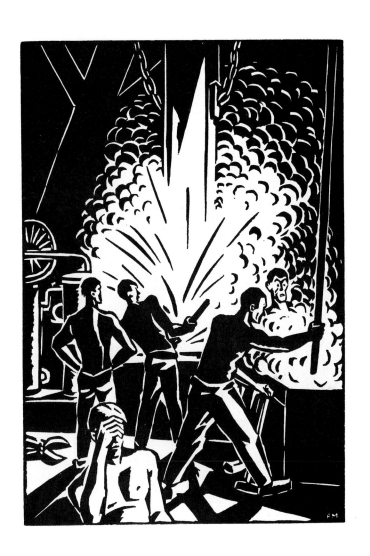

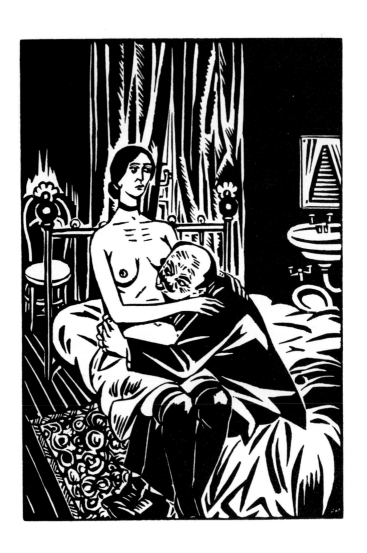

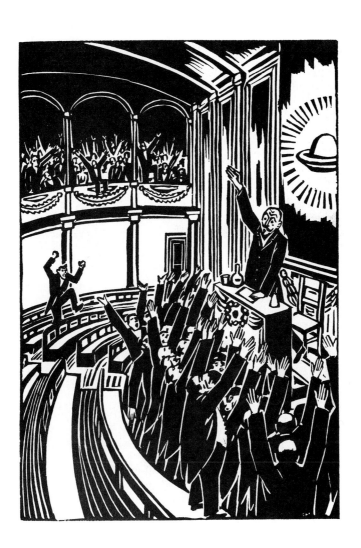

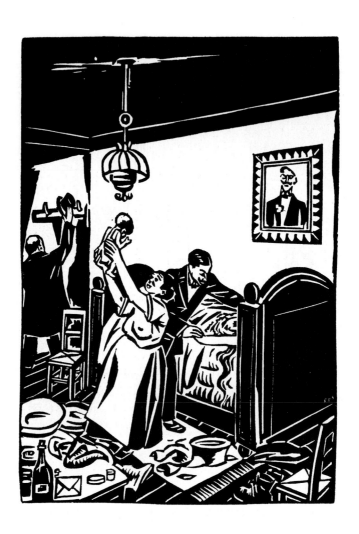

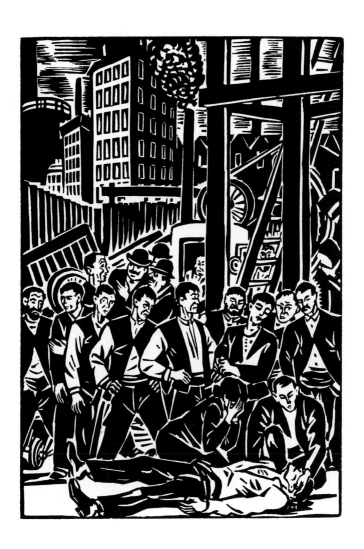

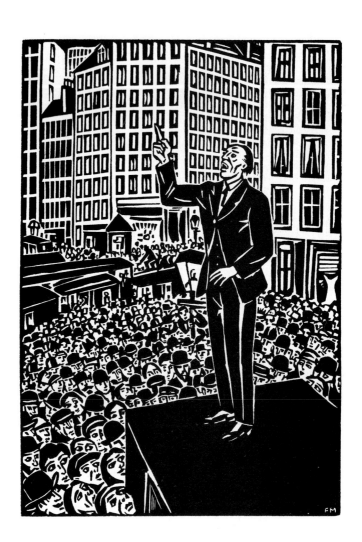

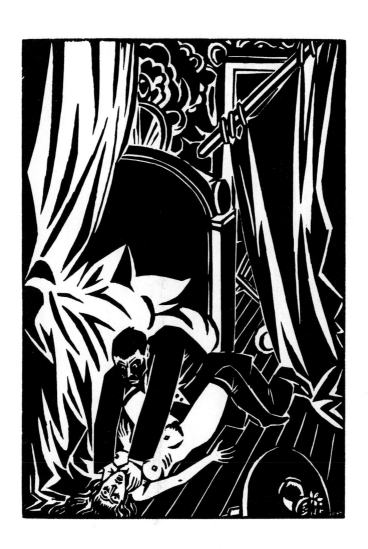

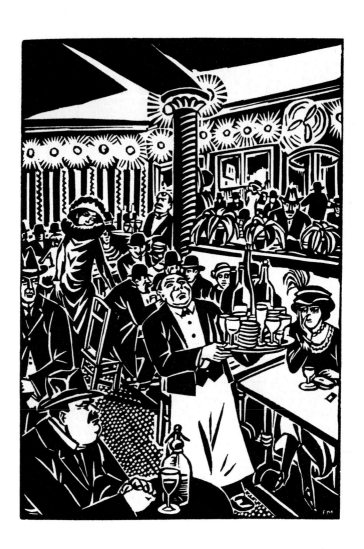

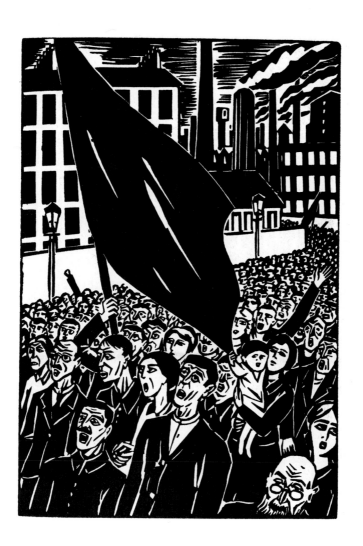

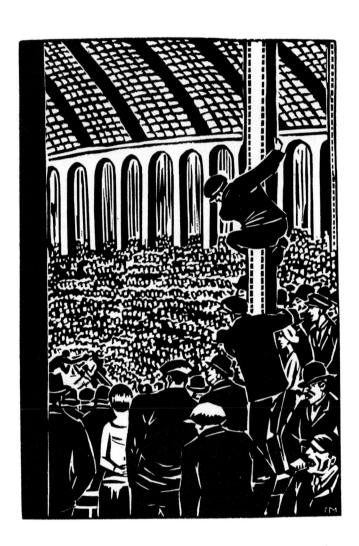

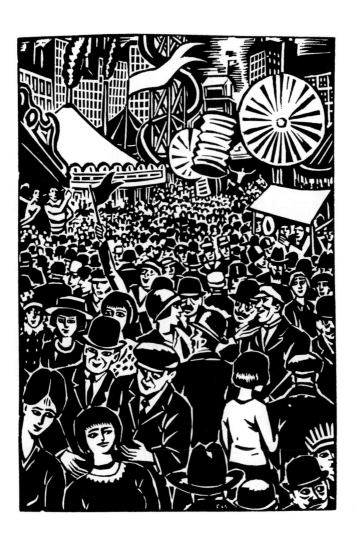

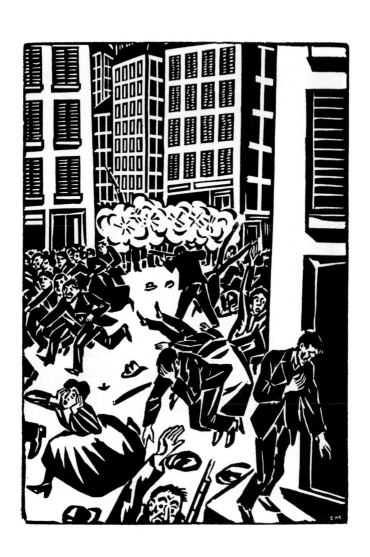

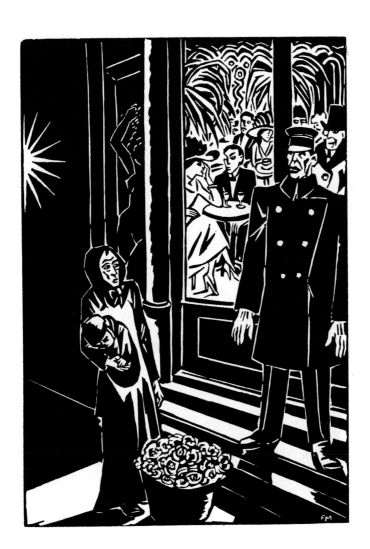

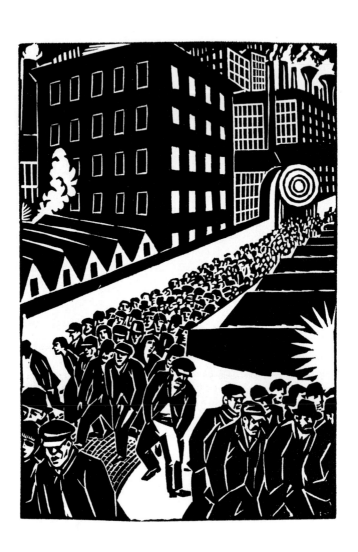

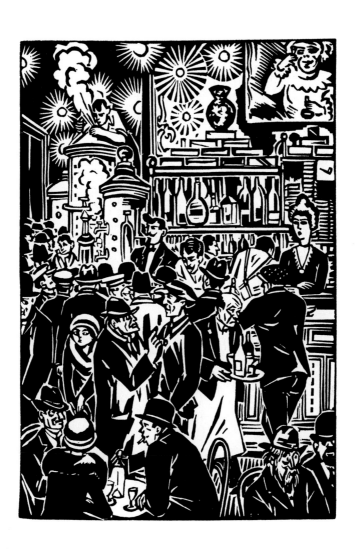

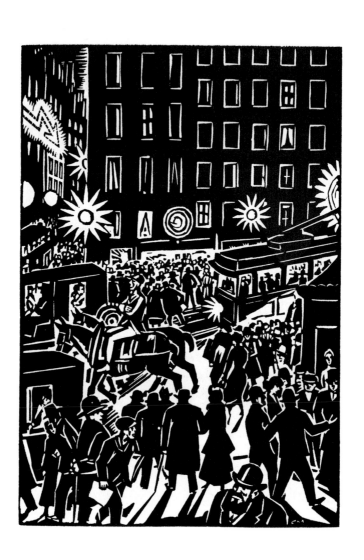

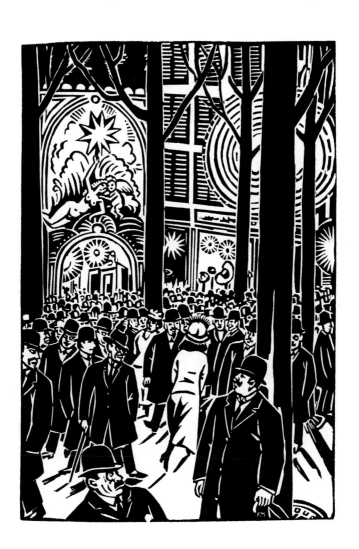

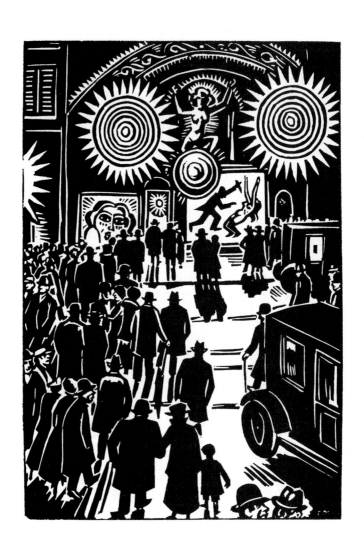

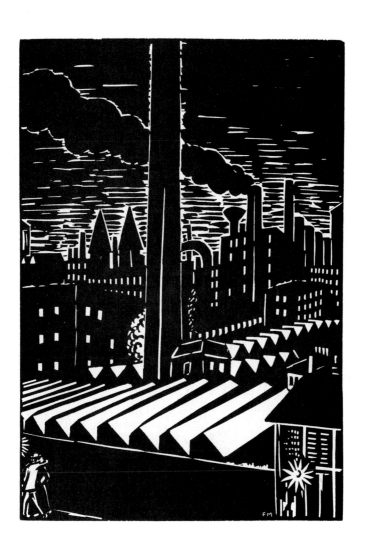

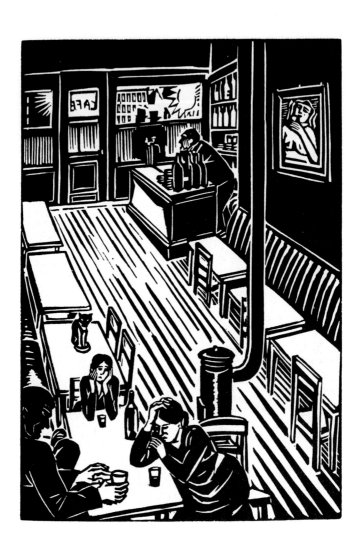

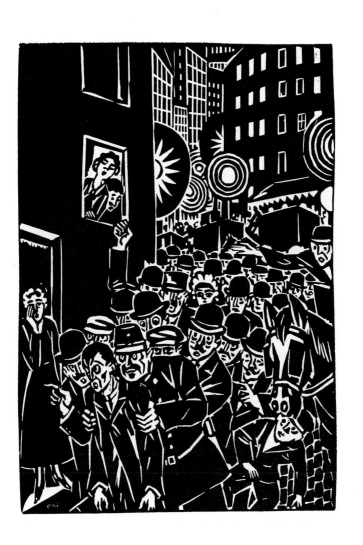

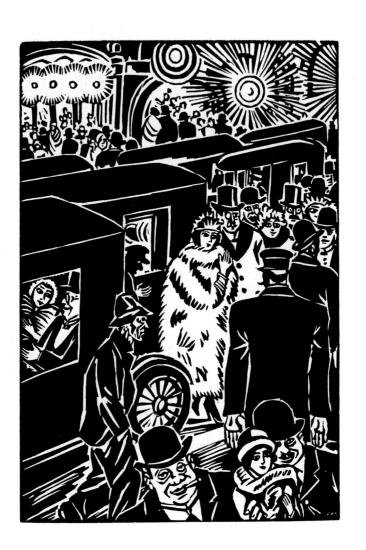

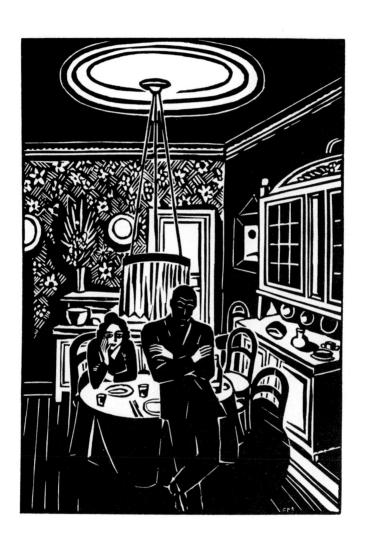

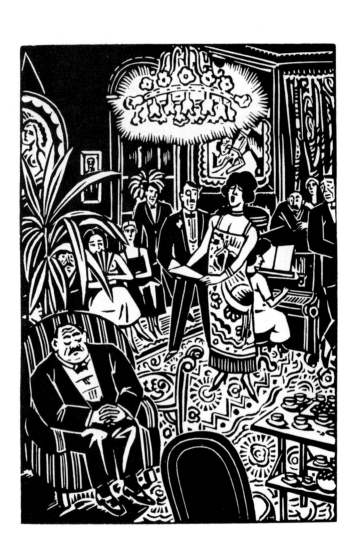

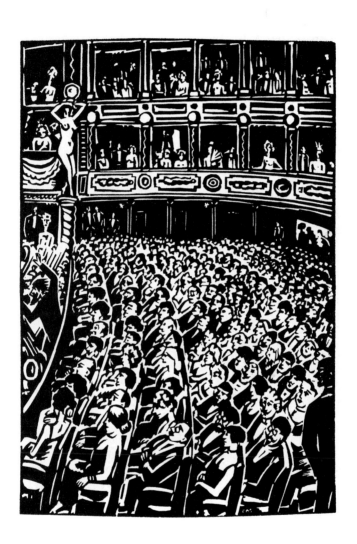

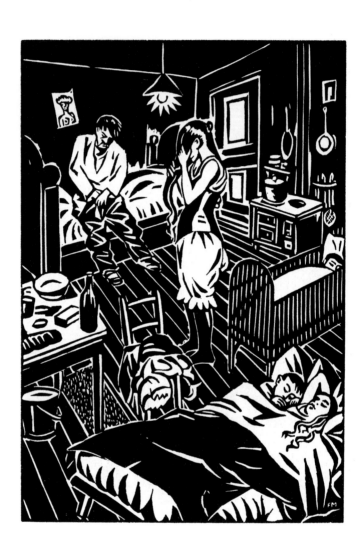

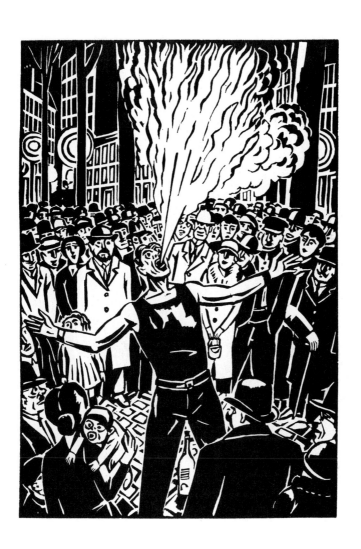

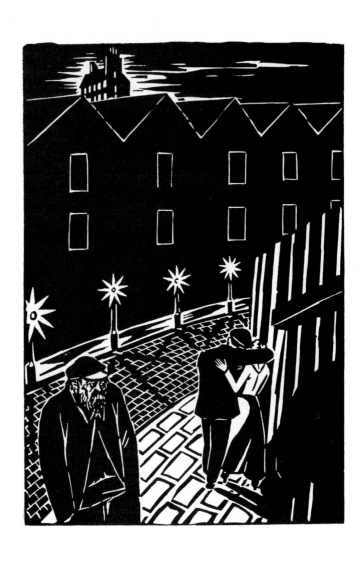

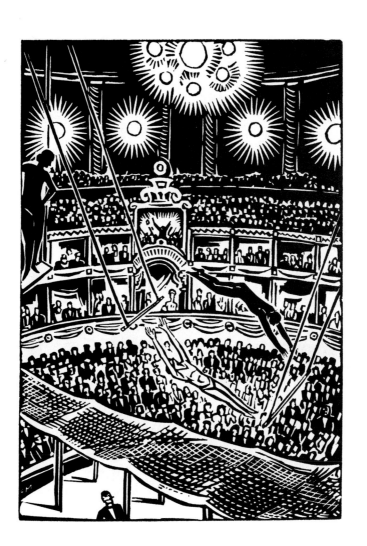

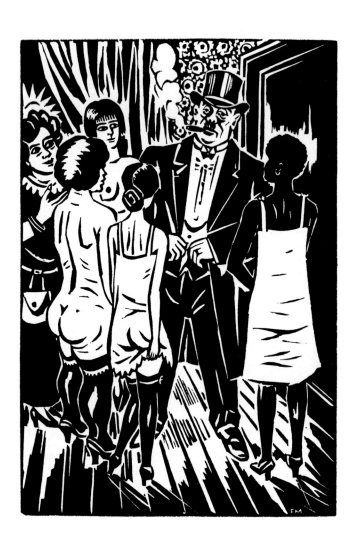

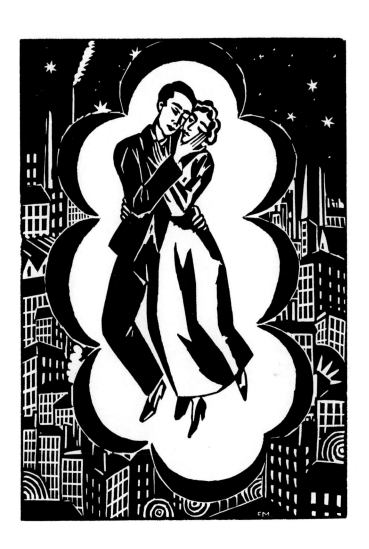

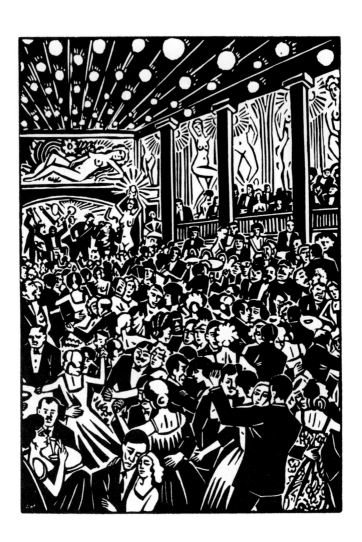

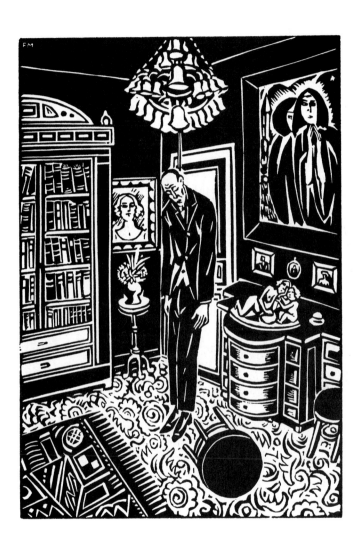

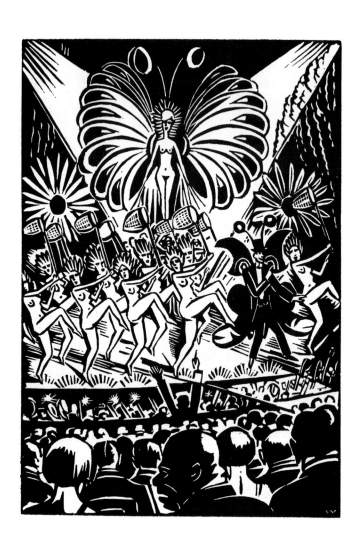

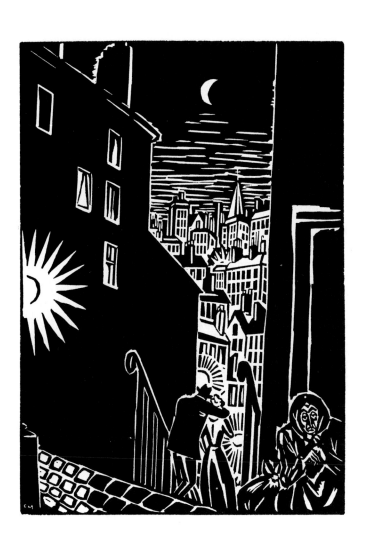

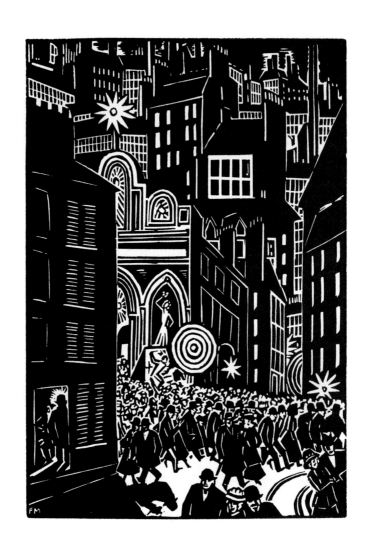

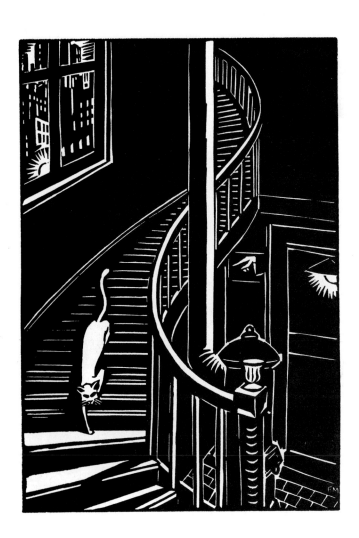

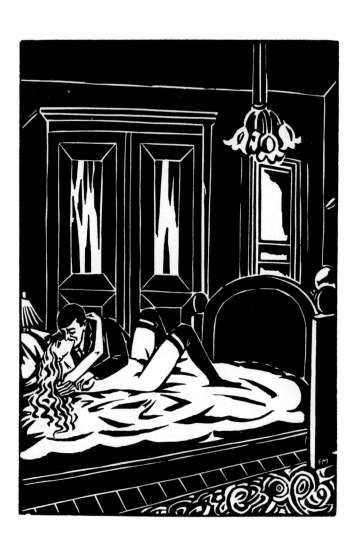

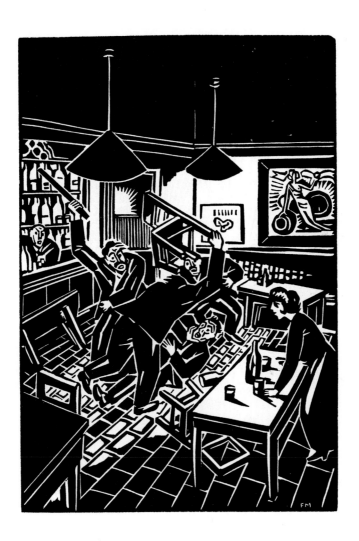

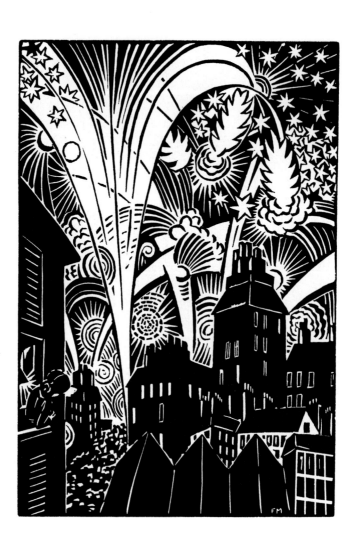

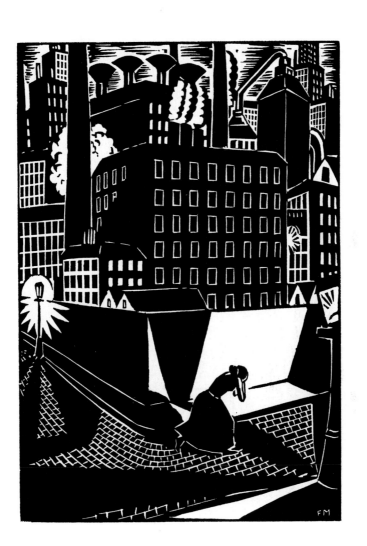

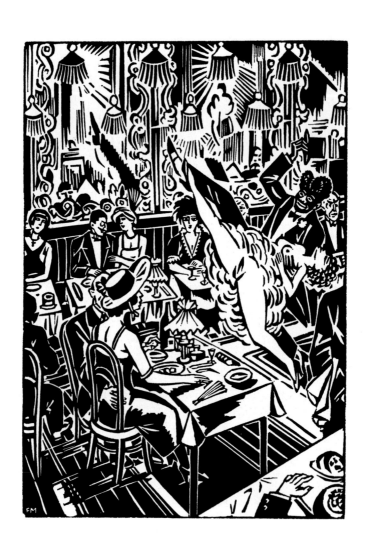

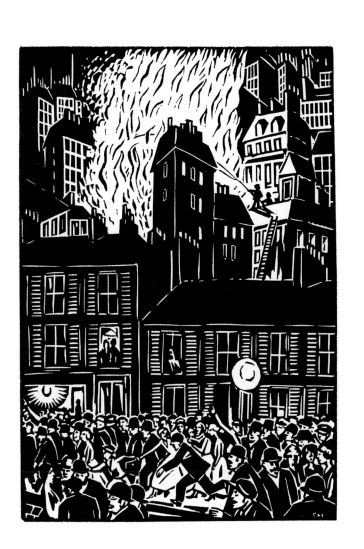

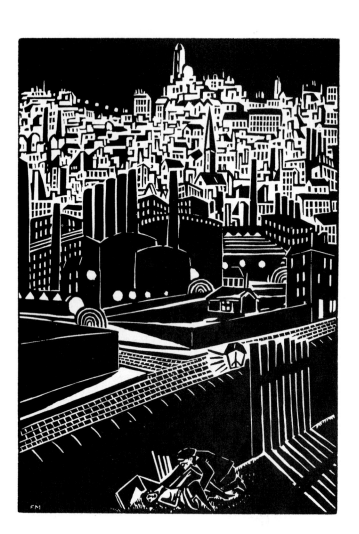

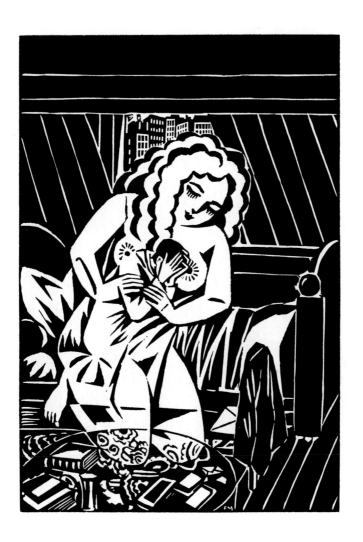

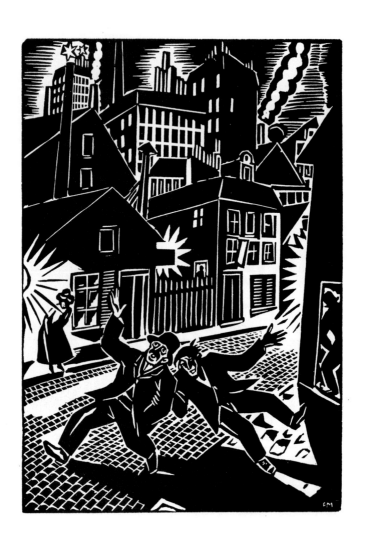

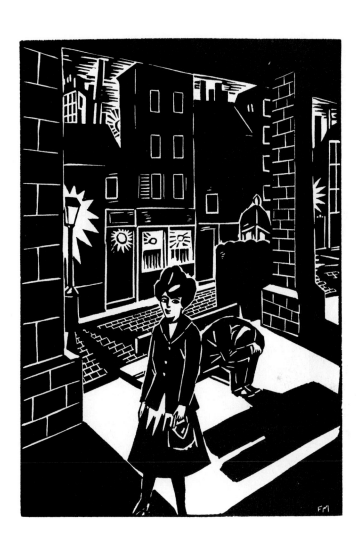

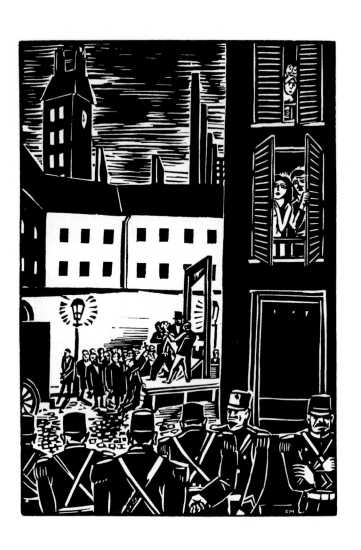

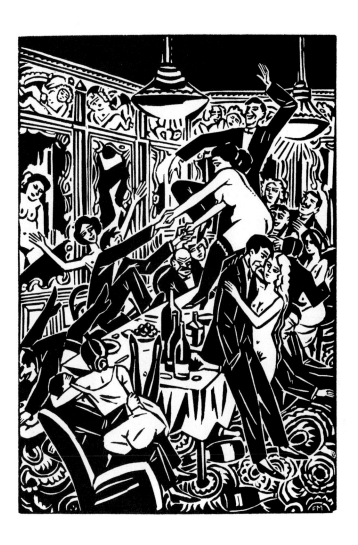

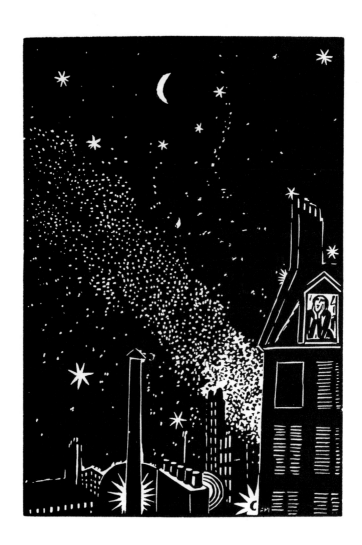